IMAGES
of America

NEW LONDON
FIREFIGHTING

Firefighters do not get a day off from work because of the weather. Here the 1977 American LaFrance 85-foot aerial tiller races to a call on Montauk Avenue despite heavy snow falling in the winter of 2002. In the background is the Harbor School.

On the cover: Please see page 20. (Courtesy of the New London Fire Department.)

IMAGES
of America

NEW LONDON
FIREFIGHTING

Tara Samul

ARCADIA
PUBLISHING

Copyright © 2006 by Tara Samul
ISBN 0-7385-4537-6

Published by Arcadia Publishing
Charleston SC, Chicago IL, Portsmouth NH, San Francisco CA

Printed in the United States of America

Library of Congress Catalog Card Number: 2006923207

For all general information contact Arcadia Publishing at:
Telephone 843-853-2070
Fax 843-853-0044
E-mail sales@arcadiapublishing.com
For customer service and orders:
Toll-Free 1-888-313-2665

Visit us on the Internet at http://www.arcadiapublishing.com

This work is dedicated to the men and women of the New London Fire Department, past, present, and future. (Linocut by Cynthia Samul.)

Contents

Acknowledgments		6
Introduction		7
1.	Beginning Years: 1767–1938	9
2.	Transition Years: 1941–1985	53
3.	Recent Years: 1988–2006	103
Chief Engineers of the New London Fire Department		127
Index		128

Acknowledgments

This project could not have been completed without the support and materials of Chief Ronald Samul Sr., firefighter Stephen Wargo, and Marcia Stuart of the Public Library of New London. Thank you for your time and assistance. Thank you Cynthia Samul, Lt. Victor Spinnato, and Donald Chapman Jr. for the use of your artwork and photographs. Unless otherwise noted, all materials came from the archives of the New London Fire Department. Much useful information was found in the archives of the *Day* and Robert Owen Decker's *The Whaling City: A History of New London*. Finally, I would like to thank Ronald Samul Jr. for his scanning expertise, patience, and everlasting encouragement.

All proceeds from the sale of this book will be donated to the Dr. Carl Wies Scholarship Trust.

INTRODUCTION

The city of New London has a long and rich history beginning in 1646 when the first settlers arrived. Today the city is a thriving municipality that provides all city functions from career police, fire and emergency medical services, education, and public works services to municipal water and sewer systems. Each and every one of these municipal services contributes to the success of the city of New London. This book will focus on the evolution of one of those departments, the New London Fire Department, and its humble beginnings in 1767 to the present.

The New London Fire Department's first chronicled history begins in 1767, when Nathaniel Shaw Jr. presented the city with its first fire engine. At that time, the technology involved a tub of water on wheels with a hand pump and suction pipes. However, this fire engine was an important asset to the city, as demonstrated in 1781, when the British, led by Benedict Arnold, burned New London, including the building that normally housed the fire engine. Fortunately, local patriots took the risk and saved the fire engine by hiding it in the woods until the British had left New London.

In 1786, the first regular fire company was established when Ebenezer Douglas was appointed captain with authority to enlist 12 men. The alderman and mayor provided the funds to build a dedicated building to hold the first company, known as the George Washington's. These men were the founding fathers of what is now known as the City of New London Fire Department.

By 1849, four companies existed. For the next 50 years, companies were disbanded and reorganized. By 1900, six companies were formed with two new companies being added in 1906 and 1909.

In the early 20th century, numerous changes to the fire department began to form a modern and dynamic organization that has evolved into the New London Fire Department as we know it today.

In 1903, an American LaFrance steam-propelled chemical and hose wagon was purchased for $5,500. This unit was claimed to be the first self-propelled fire engine in the United States. Affectionately called "Old Maud," the unit proved to be slow and unreliable but remains as a major step in the evolution of the New London Fire Department.

In 1908, the fire chief's position became a permanent appointment, and a fire marshal was appointed in 1912. During the 1920s, paid drivers were appointed, badges were introduced, and fire apparatus were motor driven with mechanical water pumps, utilizing the municipal water supply and the fire hydrants located throughout the city.

The members of the New London Fire Department experienced one of their most demanding, dangerous, and historic calls to service in 1938. Most New Englanders are familiar with some

portion of the great hurricane of 1938 and the destruction it caused throughout New England and within New London. New London firefighters fought a conflagration on Bank Street, which extended from south of Sparyard Street and north to Golden Street. During the height of that destructive hurricane, New London firefighters battled the conflagration in chest-deep water for many hours. Many buildings were destroyed, including a fire station, but the fire was ultimately stopped and extinguished, saving many more buildings in the fire's path.

While the appearance of the current fire department has evolved from the 1940s to today's diesel-powered vehicles that can pump over 1,000 gallons of water per minute, specialized hydraulic-powered rescue tools, fire-resistant personal protective clothing, and self-contained breathing apparatus, the New London Fire Department's main asset, the individual firefighters, retain the same high standards of professionalism and dedication to service as those citizens who founded the same department 240 years ago. These individual firefighters answer the call for the same reasons for which all fire departments are founded: the protection of life, to stabilize and eliminate emergency conditions, and the conservation of property. All modern fire department emergency responses continue to be based on these three objectives.

As the current fire chief of the New London Fire Department, I am proud and pleased to be a part of the rich and historic traditions of the New London Fire Department. While the modern world has added many new responsibilities to local fire departments, these new challenges are taken on with enthusiasm and zeal. The fire department has and will always be a very dynamic organization requiring changes in training, equipment, and innovation that will support successful operations during any circumstances, including fire suppression, emergency medical incidents, extreme weather incidents, transportation incidents involving mass casualties, hazardous materials incidents, and weapons of mass destruction and those that are chemical, biological, radiation, nuclear, or explosive in nature, as well as any other threat to the city or its inhabitants.

This book is a moment in time where we look back at the fire department's contribution toward the success of the city of New London. We are honored to have followed in the footsteps of those who have served before us and privileged to serve and hopefully improve the city and the City of New London Fire Department for those who will follow.

<div style="text-align: right;">
Chief Ronald J. Samul Sr.

May 2006
</div>

One

BEGINNING YEARS
1767–1938

On September 6, 1781, Gen. Benedict Arnold, a native of New London County siding with the British, set New London ablaze. This was to be one of New London's most disastrous fires. The British burned 143 buildings, including 65 houses, 31 stores, 18 shops, 20 barns, and 9 public buildings. Nearly all the shipping of the port burned except those schooners and sloops that were able to flee upstream. (Courtesy of Public Library of New London.)

This is an 1864 Sidestroke pump engine on the side of the Niagara Engine Company No. 1 quarters on Sparyard and Bank Streets. The Niagaras were the oldest active company in New London. They were originally organized in 1786 under Ebenezer Douglas as the George Washington's Engine Company but would reorganize in 1844 as the Niagara company in honor of a hand pumper they received that year and was said to throw a stream of water like Niagara Falls. The company disbanded in 1850 and reorganized yet again that same year as the Niagara Engine Company No. 1. (Courtesy of Public Library of New London.)

The 1864 Sidestroke pump engine is in front of the Niagara Engine Company No. 1 quarters on Sparyard and Bank Streets with some of the volunteers.

The *November 18, 1853 fire in the Old Methodist Church* painting was done by Preston Hamilton, a slave belonging to Asa Otis. The engine depicted is the type the Niagaras had at the time. (Courtesy of Public Library of New London.)

The New London Fire Department's guide and reference book provided the firefighters with official department rules and regulations and a street directory. It was expected to be carried on their person at all times. The guide and reference book was also sold to the public for benevolent purposes.

11

Sebastian D. Lawrence, one of the wealthiest merchants of Connecticut, served as the president of the Whaling Bank of New London and presented to the city a monument to honor New London's bravest. In 1897, Lawrence had the firemen's monument built for $3,500 and placed in front of the 1784 New London County Court House on Huntington Street. On July 4, 1898, the monument was dedicated in front of hundreds of firemen. This is a souvenir ribbon given to the guests of the Niagara Engine Company No. 1. The monument now sits in front of the North Station on Broad Street.

John H. Stanners is believed to be the first paid fire chief, appointed in 1900 and running the department until 1922. In 1908, his position became permanent. Under his leadership, the department moved progressively forward into the 20th century. He retired with over 50 years of service.

Pictured is the apparatus used by Niagara Engine Company No. 1 around the beginning of the 20th century. The makers of Niagara's horse-drawn Steamer Metropolitan showed a similar make in Paris at the exposition of 1900 and gained the distinction of being able to throw the highest stream than any other make. This accomplishment brought much satisfaction to the Niagara Engine Company.

"Old Maud" was the name given to this 1903 American LaFrance Niagara steam-propelled chemical and hose wagon. It was the first self-propelled piece of fire equipment purchased and used by a community in the United States. On arrival day, the apparatus paraded up State Street and collided with a carriage. It was a triumphant and troubling day indeed. Old Maud was also very inefficient climbing hills with any altitude. However, at the time, this engine was the most advanced type of equipment to fight fire.

Old Maud was purchased for $5,500 by the Niagara Engine Company No. 1 at its own expense. Old Maud was in service until one night in 1911 when an alarm came in, and in a race to the scene, the second operator forgot to pump water into the boiler for steam and Old Maud exploded.

This is a 1912 Oldsmobile, squad body from a remodeled touring car, assigned to Niagara Engine Company No. 1. Pictured from left to right are Thomas H. Shipman, Duckie Swanson, Clarence Holdredge, Harry Rogers, and Edward Swanson.

This 1912 American LaFrance triple combination pumper was purchased in 1912 for $6,500. It had one 35-gallon chemical tank. Pictured from left to right in front of the Shaw Mansion (New London County Historical Society) are unidentified, Thomas H. Shipman (driver), Edward Swanson, and Duckie Swanson. This apparatus was out of service in 1920.

This is a 1921 American LaFrance 750 gallons-per-minute pumper purchased for $10,750.

AMERICAN-LAFRANCE FIRE ENGINE COMPANY, INC.

GENERAL OFFICE
ELMIRA, NEW YORK, U.S.A.

SALES MANAGER'S OFFICE
WHITEHALL BUILDING - 17 BATTERY PLACE
NEW YORK. March 6, 1915.

BRANCHES:
NEW YORK. DENVER.
BOSTON. DALLAS.
ATLANTA. PORTLAND
CHICAGO. CINCINNATI.
SAN FRANCISCO.

Hon. Board of Fire Commissioners,
 New London, Connecticut.

Gentlemen:--

This letter is attached to and forms a part of our proposal for motor city service truck.

We hereby agree to furnish one Six-Cylinder Motor City Service Truck, to be built strictly in accordance with specifications and delivered to the City of New London in 60 working days from date of acceptance of contract, for the sum of Six Thousand Five Hundred ($6,500.00) Dollars, less three (3) per cent. for cash in ten (10) days after delivery and acceptance of Truck.

If the ladder equipment we specify is not suited to the Board, we will make any changes required or add any equipment within reason.

We will further agree to inspect apparatus every three months or, if the Board should require an inspection oftener, we will arrange with a local mechanic, one that the Board approves of, to make an inspection after each run.

Respectfully submitted by,
AMERICAN LAFRANCE FIRE ENGINE CO. INC.

BY *Charles R. Brown*
AUTHORIZED LOCAL AGENT.

A letter from the American LaFrance Fire Engine Company outlines its proposal to the New London Board of Fire Commissioners for the 1915 six-cylinder Motor City Service Truck.

Pictured in 1946, driver Alfred Stoll is in the 1915 Seagrave motor city service truck. The truck was purchased in March 1915 and put into service on May 6, 1915. The cost was $6,500, and there were 424 feet of ladders and a 60-gallon booster. Notice the life net on the front side. This apparatus was assigned to F. L. Allen Hook and Ladder Company No. 1. It eventually went out of service and was sold as junk on May 27, 1947.

Truck Company No. 1, driven by William "Fat" Kiely, exits F. L. Allen station on Bank Street. F. L. Allen Hook and Ladder Company No. 1 formed in 1866 and was named in honor of the Mayor Frederick L. Allen. Its motto was "We raze to save, we raze to rescue." Its firehouse was a brick building on Bank Street just a few yards down the street from the present-day fire headquarters. The house was sold in 1944 and has been in private use ever since. After the 1938 hurricane, the city purchased property on Bank Street and built a duplex station in which the Hooks and Niagaras resided.

This is a 1930s parade heading south on State Street past the Crocker House. Kiely is driving F. L. Allen Hook and Ladder Company No. 1's 1916 Seagrave motor city service truck.

Kiely is believed to be the heaviest firefighter in the world. He was appointed a permanent fireman on November 1, 1922, and died November 30, 1939, at the age of 42 of a cerebral hemorrhage. Kiely was six feet tall and weighed 650 pounds. In 1929, Kiely's waist measurement was 64 inches; in 1937, he had grown to a 74-inch waist; and in 1939, he was measured at 80 inches. It took three yards of cloth to make his pants. It was rumored that he slept on the running boards of the engines because it took him too long to get down from the upper levels of the firehouse. He served the city well for 17 years during the 1920s and 1930s.

The handmade foam unit was constructed on a Chevrolet chassis costing about $10 and was put into service in 1925. It carried 2,000 pounds of Foamite powder and a two-and-a-half-inch hopper.

Nameaug Engine Company No. 2 is pictured in 1855 with its hand pumper and hose reel at the corner of Union and Masonic Streets. The Nameaug Company formed on February 4, 1850, after previously being the Reliance Company and then the Independent Blues. On April 18, 1850, it was recognized by the town council and was appropriated funds for new hose and a hose cart. This action caused many hard feelings in the other companies as their requests were not granted. The other companies all voted to disband, leaving only the Nameaugs to protect the city for a period of several weeks. Because of the breech between the city and the other volunteer companies, the Nameaugs may lay claim to having been the oldest active company in New London. The company's quarters were located on Masonic Street.

22

Nameaug Engine Company No. 2 officers pictured are, from left to right, (first row) William E. Cane (second assistant), Isaac W. Thompson (foreman), and Charles L. Ockford (first assistant); (second row) Samuel T. Adams (secretary) and Eldred P. Prentis (treasurer). (Courtesy of Public Library of New London.)

Charles L. Ockford was the first assistant of the Nameaug Engine Company No. 2. He later became chief of the department from 1894 to 1899. (Courtesy of Public Library of New London.)

A close-up shot of the Nameaug hose reel dates from around 1850. (Courtesy of Stephen Wargo.)

Nameaug Engine Company No. 2's 1920 Seagrave motor city service truck, purchased for $11,700, is in front of the quarters on Masonic Street.

Nameaug Engine Company No. 2's quarters on Masonic Street are shown in the 1920s. This building no longer stands.

Charles H. Rose had a long and illustrious career in the New London Fire Department. He is shown here in 1893 as the foreman of the W. B. Thomas Hose Company No. 3. He became a fireman in November 1872 at the age of 16 when he joined the Relief Hose Company. Rose later went on to become the chief of the department from 1923 to 1926. He retired with 54 years of service to the city.

A 1905 horse-drawn hose carriage was purchased for $1,200 for the W. B. Thomas Hose Company No. 3. Soon thereafter, the company purchased two white horses at the cost of $400 and named them Frank and Joe after their drivers. It was the only company to maintain its own horses and rent them to the city for fire use.

In 1913, W. B. Thomas Hose Company No. 3 became mechanized with the purchase of this Pope Hartford combination hose and chemical wagon for $6,500. The apparatus had a 35-gallon booster tank and 1,000-foot hose capacity. It was stripped of essential equipment and junked on November 15, 1937. Driver Frank Sullivan is shown. Notice the New Haven line car in the background to the right.

The 1916 Seagrave 750-gallon pumper is exiting the W. B. Thomas Hose Company No. 3 station at the junction of Rosemary, Cole, and Williams Streets.

W. B. Thomas Hose Company No. 3 formed sometime in the early 1800s as the Relief Hose Company. It is believed it disbanded in 1850 with the other volunteer companies over the Nameaug dispute and did not reorganize until 1861. W. B. Thomas Hose Company No. 3 went through a series of moves: its first quarters were on Richards Street, then on the corner of Huntington and Williams Streets, followed by a move to the corner of Main Street, and finally, in 1905, it moved into the first of two firehouses at the junction of Rosemary, Cole, and Williams Streets in Hodges Square. This is the 1905 building shown in 1939 before construction began for the second time on the same site.

27

This is a 1917 Seagrave triple combination pictured in 1938. The engine was purchased on September 8, 1917, for $8,500 and put into service that December. It had a 125-gallon booster, 750-gallons-per-minute pump, and 1,000-foot hose capacity.

Fire departments have always stressed fire prevention to the public. Here the W. B. Thomas Hose Company No. 3 is seen in May 1928 preparing to drive through the neighborhoods of New London with a sign attached to the 1913 Pope Hartford combination hose and chemical wagon. Sirens would blare to get residents' attention.

This is the W. B. Thomas Hose Company No. 3's 1939 quarters. The two-and-a-half-story Colonial-type structure was built for approximately $28,600. The station was eventually removed during the 1960s to make way for the Groton–New London Bridge.

Konomoc Hose Company No. 4 began its service with this four-wheeled hand-drawn hose cart the same year that New London's hydrant system started, in 1873. The company disbanded in 1874 because it was rumored and suspected that some members were responsible for a rash of small fires. It reorganized in 1876.

THIRD ANNUAL FAIR
KONOMOC HOSE COMPANY

To be given away
$1500.
For 10 cents

To be given away
$1500.
For 10 cents

AT LAWRENCE HALL, NEW LONDON, CONN.

NOVEMBER 14-16-17-18-19-20-21-23-24-25, 1914

I hereby contribute TEN CENTS to the above.

SERIES 1 No. 912

Shown here is a ticket stub from an annual fair the Konomoc Hose Company No. 4 used to sponsor. The volunteer companies all had a social side, and these events usually proved very popular. (Courtesy of Stephen Wargo.)

This was the original home of the old short-lived Reliance Company No. 5, later Konomoc Hose Company No. 4, on Church Street. It was used by Konomoc Hose Company No. 4 until 1906 when it moved into the Union Street School.

The Konomoc Hose Company No. 4 volunteers, including band members, are pictured in front of the Union Street School, built in 1844. The name Konomoc was used in honor of Lake Konomoc, which served as the city's water supply. (Courtesy of Stephen Wargo.)

This 1918 Seagrave motor city service truck, pictured about 1920 with Chief Charles H. Rose as passenger, was originally assigned to Konomoc Hose Company No. 4 and later transferred to W. B. Thomas Hose Company No. 3 and eventually to Nameaug Engine Company No. 2. In March 1950, this engine was sold to the Ashford Volunteer Fire Department.

This is a 1917 Seagrave triple combination that was eventually transferred to the W. B. Thomas Hose Company No. 3 in 1925. Chief Rose is standing on the ground, and Alfred Harvey is in the driver's seat. The other man is unidentified.

The 1925 Seagrave 75-foot aerial tiller purchased for $12,900 is shown exiting the Konomoc station on Union Street. The driver is Alfred Harvey, William Serafin is the tillerman, and Tom Enos is the rider. The Konomoc Hose Company No. 4 changed to the Konomoc Ladder Company No. 2 when this truck was purchased in 1925.

This 1927 Chevrolet Roadster was purchased in July 1928 and assigned to the deputy chief. It went out of service on January 27, 1934, and a $24 allowance was granted toward a trade-in for a Ford sport coupe. Pictured from left to right are Joseph Facas, William Kiely, and Deputy Chief Calvin Edmonds.

Fire headquarters were housed at 66 Union Street, the Konomoc house, until the late 1960s when the department was consolidated and headquarters were moved to the Niagara Engine Company No. 1 and F. L. Allen Hook and Ladder station on Bank Street. This building no longer stands.

This 1919 American LaFrance chemical and hose truck assigned to C. L. Ockford Hose Company No. 5 is shown at the time of delivery in 1919. The rig was purchased in 1919 for $7,285 and was sold in 1945 for $200.

C. L. Ockford Hose Company No. 5 was founded in 1895. The city rented a house owned by E. T. Brown at Howard Street and Pequot Avenue to serve as the company's quarters from 1895 until 1943. Around 1910, a fire partly destroyed the house, and a new one (pictured) was built on the grounds.

In 1943, C. L. Ockford Hose Company No. 5 moved to larger quarters on Riverview Avenue near Caulkins Park.

This 1943 Seagrave triple combination, seven-man cab was purchased in November 1942 for $9,412 and assigned to the C. L. Ockford Hose Company No. 5. It had a 150-gallon booster, two-stage 750-gallon-per-minute pump, and 1,200-foot hose capacity with a loaded weight of 14,680 pounds.

Pequot Engine Company No. 6 was the next to last volunteer company to form in New London. It was organized in 1906 by Col. E. T. Kirkland for the protection of the Pequot Colony. Colonel Kirkland held the position of foreman from the time of Pequot Engine Company No. 6's inception to his death in 1923. Between 1909 and 1910, the company was accepted by the city and began to receive financial aid.

This old hand-drawn hook and ladder truck was presented to the company in 1907 by Dr. William Appleton.

One of the landmarks of the coast, the Pequot Hotel was completely destroyed on May 7, 1908. The general opinion of the origin was that it was incendiary; however, there were no clues to work from to prove this. Assistant Chief Charles H. Rose is directing the firemen.

Remains of the Pequot Hotel fire of May 7, 1908, are seen here. The Pequot Hotel was the third hotel to be completely destroyed by fire in that section of the city since the late 1850s. The Brown Tavern and the Alhambra were the other two.

This is the Pequot Engine Company No. 6's first gasoline-powered engine, a 1912 Locomobile chemical and hose wagon purchased for $6,000. Just behind it is the first squad car, also a Locomobile, purchased in 1915 for $1,025. The company moved into the quarters on June 11, 1908. The bell from the Pequot Chapel was used as a fire alarm.

The city purchased this 750-gallons-per-minute piston-type pump Ahrens-Fox pumper in 1926 for $13,000. It was stationed in the south end of the city at Pequot Engine Company No. 6. It served the community well until its replacement in 1954.

Testing is performed on the engine of the Ahrens-Fox pumper.

Firefighter Joseph M. Corkey stands in front of the 1926 Ahrens-Fox pumper. Corkey later became the fire chief on September 6, 1959, and served until January 7, 1965.

Pequot Engine Company No. 6's first quarters were in a private resident's stable. Meetings were held in Col. E. T. Kirkland's stable. In 1922, the firehouse was enlarged to twice its original 1908 size, costing about $6,000. It was the only company-owned firehouse in the city. The bell from the Pequot Chapel was kept and used.

Unlike today's stringent entry requirements, there were not many requirements or standards to become a volunteer firefighter, as is illustrated on this membership application for the Pequot Engine Company No. 6. (Courtesy of Stephen Wargo.)

Northwest Hose Company No. 7 was organized in December 1908 by the influential citizens of the northwest section of the city. Its first quarters were in this old house owned by the city on Brainard Street. The old Nameaug steam engine was stored there. This is Northwest Hose Company No. 7's first piece of apparatus, a two-wheel hose reel, handed down from one of the older companies.

Northwest Hose Company No. 7's 1914 Thomas Flyer made-over touring car had one 35-gallon chemical tank. Pictured from left to right are Fred Bell, Joe Silva, William Belcher, and Malcolm Scott.

A side view of the 1914 Thomas Flyer is seen here. It was placed into storage in June 1921 when the city purchased a Seagrave triple combination pumper in 1921 and later junked in October 1928.

Neighborhood kids take the opportunity to have their picture taken with Chief Charles H. Rose at the Northwest station in the 1914 Thomas Flyer.

The Northwest Hose Company No. 7 officially changed to an engine company in 1920 with the purchase of the Seagrave triple combination pumper. This opening house program was given to all attendees of the formal dinner and dance party celebrating the beginning of the new Northwest quarters.

Northwest Engine Company No. 7's new station built in 1920 on land where it originally stood at 58 Brainard Street. The station was built to receive the new Seagrave pumper.

This 1920 Chevrolet was purchased in November 1920 for $750 and later assigned to Chief Charles H. Rose in 1923. While responding to an alarm, Chief Rose was in an accident at Green and Pearl Streets. He sustained a broken leg and other injuries, which caused his retirement after 54 years of service in the department. The car went out of service and was junked in May 1926.

The 1926 Nash seven-passenger touring car was purchased as a replacement in May 1926 for $1,800. It was assigned to the new chief of the department, Thomas H. Shipman. It was used until late January 1934.

Chief Thomas H. Shipman served the department from May 20, 1926, until June 23, 1953. Chief Shipman is currently the longest-serving paid chief with 27 years of service in that position. Under his leadership, a paid force began in May 1927.

Chief Thomas H. Shipman's car is pictured in front of fire headquarters at 66 Union Street. This car was wrecked in the hurricane of 1938. It was used as a wrecker by the water department until World War II and later returned to the fire department to be used as a civil preparedness rescue truck.

This 1939 Cadillac passenger coupe was put into service in May 1946 for $1,500 and was assigned to Chief Shipman. It went out of service in November 1952 with 130,000 miles.

The Second Congregational Church on Broad Street suffered complete interior damage from a blaze on December 3, 1926. Defective electrical wiring was the most probable cause. The fire originated in the organ bellows room behind the sanctuary. The Konomoc Ladder Company No. 2 utilized its newly purchased Seagrave 75-foot aerial tiller fighting the blaze 40 feet above the ground. (Courtesy of Public Library of New London.)

Note the time on the steeple clock. The clock in the tower of the Second Congregational Church continued to toll despite the raging fire. (Courtesy of Public Library of New London.)

Spectators stand around to witness the 1934 Good Friday Hose Reel Race. Among the volunteer fire companies, teams competed to be the quickest to pull the reel up Bank Street and connect the hose to a hydrant.

The hurricane of 1938 leveled a number of business blocks on Bank Street and completely destroyed Ocean Beach on September 21, 1938. The hurricane hit the city at 3:00 p.m. and raged for three hours. Wind gauges broke at 120 miles per hour. The fire, wind, and water caused $4 million worth of damage. There had not been this much ruin since Gen. Benedict Arnold burned the city during the Revolutionary War. The fire began in this building at the end of Sparyard Street. It took Northwest Engine Company No. 7 nearly four hours to get down Brainard Street as it had to remove the fallen trees from the street. Before the fire was under control, 400 people, including all of the paid firemen, men from the submarine base in Groton, the U.S. Coast Guard and Coast Guard Academy, and private citizens, helped to extinguish it. (Courtesy of Stephen Wargo.)

This handmade lighting plant trailer was built on a Chevrolet chassis. It was put into service two weeks after the hurricane destroyed much of New London. It was housed at the Pequot Engine Company No. 6 station on Lower Boulevard.

Two
TRANSITION YEARS
1941–1986

On September 24, 1941, at 3:30 p.m., the New England Steamship Company Pier near Union Station was ablaze for four hours. Police estimated between 7,000 and 8,000 spectators extended from Shaw's Cove to Union Station. The combination of 11 freight cars loaded with coal and creosoted lumber of the burning pier produced huge billows of smoke visible for miles. Twenty-three firemen were injured, none seriously. Pier loss was estimated at $150,000. (Courtesy of Stephen Wargo.)

Civil defense apparatus used from 1941 to 1945 during World War II is pictured at Caulkins Park behind the C. L. Ockford Hose Company No. 5 on Riverview Avenue.

(COPY)

December 8, 1941.

GENERAL ORDER NO. 26

Due to the fact that we are now at war with a foreign power and the strategic location of the city as well as Army, Navy, Coast Guard, Electric Boat Company and defense plants in this vicinity are liable to sabotage at any time,..all permanent men of this department will remain in a continuous state of alert.

It will be the strict duty of every off-duty fireman to answer all alarms that may come to his attention. From this date a roster of all men answering these alarms will be kept.

No permanent man will leave the city without first notifying headquarters, and then he must leave his address if possible.

A All permanent men will check with operator at headquarters, telephone numbers where you can be reached for emergencies.

When relieving shifts at 6:00 P.M. and 8:00 A.M., the man going on duty will inspect his apparatus carefully to be sure that all is in proper order for instant use.

Any instance of a nature that may be suspicious in or around the engine house will be immediately reported to the Chief and arrangements will be made to lock all doors during the night.

It is suggested that all firemen keep tuned in as much as possible to our local Radio Station " WNLC " who have kindly agreed to transmit all emergency calls.

Chief of Fire Dept.

Chief Thomas H. Shipman issued this general order the day after the attack on Pearl Harbor. (Courtesy of Stephen Wargo.)

This factory photograph shows the 1943 Seagrave triple combination seven-man cab. It was purchased in November 1943 for $9,412 and assigned to Niagara Engine Company No. 1. It had a 150-gallon booster, two-stage 750-gallons-per-minute pump, and 1,200-foot hose capacity.

Fire damaged this Howard Street house on the afternoon of June 5, 1947. The fire broke out in a shed (in the forefront of the photograph) and spread to nearby houses. (Courtesy of Stephen Wargo.)

The side view shows the damage of the Howard Street house. The Niagara Engine Company No. 1, Nameaug Engine Company No. 2, Pequot Hose Company No. 6, and the F. L. Allen Hook and Ladder Company No. 1 were dispatched to the scene. The apparatus of the Ockford Hose Company No. 5, which would ordinarily respond to the call, was in the city shop for repairs. However, that did not prevent C. L. Ockford volunteers from responding on foot. (Courtesy of Stephen Wargo.)

57

Devlin's Ringside restaurant at 169 Bank Street on the corner with Pearl Street had extensive damage from a three-alarm fire in the early morning of December 6, 1947. The conflagration, of unknown origin, started behind a service bar on the second floor. Fire completely burned out the second-floor dining room and half of the third floor. The first floor was spared by flames but had substantial water damage. This view is looking down Pearl Street toward Bank Street. (Courtesy of Stephen Wargo.)

Konomoc Ladder Company No. 2's 1925 Seagrave 75-foot aerial tiller was one of the first pieces of apparatus to arrive on the scene at Devlin's Ringside restaurant. This view is from Bank Street. Weather conditions were less than ideal; temperatures were below freezing, causing water to freeze on both ladders and equipment. Damage was estimated at $15,000. (Courtesy of Stephen Wargo.)

Fire was discovered at the Barrows Building on State Street on December 12, 1946, at approximately 9:30 a.m. This picture was taken about 20 minutes after the fire was discovered. (Courtesy of Public Library of New London.)

Firemen attack the fire at the Tait Brothers Ice Cream Company plant at the corner of Mill and Winthrop Streets on September 16, 1948. (Courtesy of Stephen Wargo.)

Firefighter Romolo Gentilella is shown here driving Konomoc Ladder Company No. 2's 1925 Seagrave 75-foot aerial tiller down Bank Street heading toward State Street.

Firefighter Rosario DiMarco is backing Konomoc Ladder Company No. 2's 1925 Seagrave 75-foot aerial tiller into the Konomoc station on Union Street in the early 1950s. Firefighter Charlie Lusk did all of the gold leaf on the tiller. (Courtesy of Stephen Wargo.)

Firefighter Frederick Philopenia is backing the Northwest Engine Company No. 7's 1943 Seagrave 750-gallon pumper into the Brainard Street station in the early 1950s. Notice the coats drying on the fence and the hose laid out. (Courtesy of Stephen Wargo.)

Members of the Uniformed Firemen's Benevolent Association ready their float for the 1950 firemen's convention in August 1950 at the W. B. Thomas Hose Company No. 3 station. (Courtesy of Public Library of New London.)

The Uniformed Firemen's Benevolent Association heads down State Street past the viewing stand in front of city hall during the 1950 firemen's convention in August.

Firefighters Thomas Maher and Dominic Vescovi fix up used toys for the Christmas toy drive for disadvantaged kids in the basement of Union Street fire headquarters on December 9, 1950. (Courtesy of Stephen Wargo.)

The Swift Company Wholesale Meat Distributor, located at 23 John Street (where the New London Police Department is today), is seen with dense smoke pouring out on the morning of February 10, 1951. More than 30 firemen from seven companies worked for over an hour in the bitter cold to contain the blaze. (Courtesy of Stephen Wargo.)

More dense smoke can be seen pouring from every opening of the Swift Company Wholesale Meat Distributor on John Street. The smoke was toxic and yellow in color, caused by the burning of yellow pine lumber used in the building's construction. (Courtesy of Stephen Wargo.)

The Konomoc Ladder Company No. 2's 1925 Seagrave 75-foot aerial tiller is shown staged on the train tracks. The aerial tiller was only used in emergencies during this time because the ladder had been condemned as unsafe. Mohican Hotel can be seen in the background. The white rescue ambulance in the right foreground was a New London Fire Department rescue vehicle. First-aid and rescue equipment was carried in the vehicle to the scene. Additionally, it was used to transport patients to the hospital. In previous years, two taxi drivers were dispatched with an ambulance, kept at the taxi company, to the scene to transport patients for the city. (Courtesy of Public Library of New London.)

The Uniformed Firemen's Benevolent Association presented a resuscitator to the fire department. Firefighter Stanley Tansey (center) gives city council members a demonstration in June 1951.

Electrical wiring stored in the basement of the New London Lighting Fixture Company located at 86 Bank Street was responsible for much of the acrid smoke that made it impossible for firefighters to enter the building for more than an hour on October 13, 1951. The Hygienic Restaurant is directly across the street. (Courtesy of Public Library of New London.)

Konomoc Ladder Company No. 2 purchased this 1953 Seagrave 85-foot aerial tiller for $39,000. It is pictured in front of the Bank Street Niagara Engine Company No. 1 and F. L. Allen Hook and Ladder Company No. 1 station. This truck was sold in July 1988 to Cross Sound Ferry Services Inc. for $3,500.

Konomoc Ladder Company No. 2's 1953 Seagrave 85-foot aerial tiller extended to the roof of the Crocker House. This is a test demonstration in front of city hall. (Courtesy of Public Library of New London.)

68

Five persons, including a four-year old child, were killed in this early morning fire that raced through an apartment house at 32 Golden Street on March 13, 1954. More than two dozen people were in the house when the fire broke out, and most tenants were forced to jump to safety from the second and third floors. Chief Frank Sullivan is directing the placement of the ladder. (Courtesy of Public Library of New London.)

City manager Edward Henkle declared a state of emergency at 9:15 a.m. on August 31, 1954, as Hurricane Carol was pounding New London. The storm struck full force at 8:00 a.m. and had subsided by 11:00 a.m. All tracks of the New Haven Railroad, just south of Union Station, were covered by water due to the six feet of water above high tide. All through the city, trees and wires

were down. The damage, not as extensive as the hurricane of 1938, can be seen on Bank Street across from the Niagara Engine Company No. 1 and F. L. Allen Hook and Ladder Company No. 1 station.

Frank Sullivan, standing on the left, served as fire chief from July 6, 1953, to September 6, 1959. Chief Sullivan is pictured with Charles Smith during a ceremony honoring Smith and Edward Swanson as the last three charter members of Northwest Engine Company No. 7.

Fire started in a laundry chute and quickly spread to a stairwell of the 10-story Mohican Hotel on State Street on November 12, 1954, at 7:28 p.m. A general alarm was called at 7:39 p.m. with all eight volunteer companies responding. Thirty-four regular firefighters and more than 150 volunteers were on scene. One hundred and fifty people were brought out of the upper floors and put up elsewhere, including the Crocker House down the street. There were 13 ambulances from surrounding towns; however, only a few were actually needed. Extreme damage was on the main floor, shown here, as well as the fifth and ninth floors as flames shot out from the stairwells of those floors. The conflagration was brought under control by 10:00 p.m. and damage was estimated at over $100,000. (Courtesy of Public Library of New London.)

C. L. OCKFORD HOSE CO., No. 5

INCORPORATED

50 RIVERVIEW AVENUE

NEW LONDON, CONNECTICUT

January 25, 1955

Pequot Engine Co. #6
25 Lower Blvd.
New London, Conn.

Dear Sirs:

 We are wondering if your members would be interested in having a card tournament with a group from the C.L.Ockford Hose Co.

 If it is the wish of your members please advise us and we both can make the necessary arrangements.

Yours truly,

John Mc Guirk sect.

John McGuirk

The social side of the volunteer companies was very strong and highly competitive as is evident here. John McGuirk is the father of Brendan McGuirk, a present-day firefighter with over 30 years on the job. (Courtesy of Stephen Wargo.)

Fire at Dan O'Shea's on the corner of Bank and Golden Streets at 23 Golden Street occurred on December 11, 1956. There was $18,500 worth of damage, and the cause was undetermined. Notice the white hose butts in the foreground. Each company had a different color to distinguish which lines belonged to which company. Today fire headquarters (Bank Street station) still uses the white hose butts.

On the morning of St. Valentine's Day 1957, the Empire Theater and New London Wholesale Grocery located at 394 Bank Street incurred $300,000 worth of damage, including building and contents, from fire. The rear section of the building collapsed, leaving only bricks and a chimney. Four families from an adjacent building were evacuated when the structure's roof was set ablaze by sparks. (Courtesy of Public Library of New London.)

A 10-year-old boy was responsible for accidentally setting fire at Quintillian's Clothing Shop at 204 Bank Street on August 14, 1958. The boy was almost trapped in the basement of the burning building. There was $10,000 worth of damage to the building and $20,000 to the contents, most of which were clothing. (Courtesy of Public Library of New London.)

Firefighters Guido Bartolucci, left, and James Sullivan wheel a charred filing cabinet out of Quintillian's Clothing Store at 204 Bank Street on August 14, 1958, after the fire had been extinguished. (Courtesy of Public Library of New London.)

Nameaug Engine Company No. 2 is making the hydrant connection at the corner of Brainard and Amity Streets on the afternoon of July 17, 1959. Two boys started the fire on the second floor of the vacant Salvation Army building at 70 Brainard Street, causing $2,500 worth of damage. (Courtesy of Stephen Wargo.)

This was the dispatch center, located on Union Street, used up until the 1960s. A manual transmitter sent the alarm. The city dispatched for communities on the other side of the Thames River, including Ledyard and Gales Ferry. (Courtesy of Stephen Wargo.)

Joseph Vendetto, who later retired as chief fire marshal, is seen standing behind the chain-link fence looking down at the Hallam Street loading dock on May 5, 1960, around 10:00 a.m. A railroad loading platform and a crane were set on fire from sparks produced by an acetylene torch, causing about $8,000 worth of damage. (Courtesy of Stephen Wargo.)

Fire started around 1:30 p.m. in shelving placed against an old window at the rear of Corradino's Bakery located at 27 Main Street on October 9, 1961. Caruso Music Store and Studio was on the second floor. Firefighter Dominic Vescovi is on the ladder. (Courtesy of Public Library of New London.)

Firefighter Alfred "Monk" Gonsalves, sitting in the rescue car, and firefighter Anthony Basilica are in front of the Niagara Engine Company No. 1 and F. L. Allen Hook and Ladder Company No. 1 station on Bank Street.

New London's first diesel engine, a Mack 1,000 gallon per minute, was purchased in 1966 for $27,081 and put into service at the W. B. Thomas Hose Company No. 3 station. Pictured from left to right in April 1966 are firefighters David Pasqualini, John Weigel, Kenneth Edwards, and Donald Chapman Sr.

Chief James Spadaro's tenure as chief of the department ran from January 15, 1965, until March 1, 1969.

In the spring of 1967, Chief Spadaro, with stopwatch in hand, conducted time tests on Laurel Drive. The time tests were done to see how long it took the apparatus to get to different parts of the city.

This undated photograph of Romolo Gentilella was taken at the C. L. Ockford Hose Company No. 5 station on Riverview Avenue. Gentilella served as chief from March 1, 1969, to May 25, 1973.

Public safety and fire prevention education have always been taken seriously by the New London Fire Department. Firefighter Brian Bauer, on the left, and firefighter James Flannigan are at the New London Mall in early 1970 setting up a fire prevention display.

Two State Street businesses, Starr Brothers Drug Store and Calmon Jewelers, were destroyed on January 22, 1970, resulting in $200,000 worth of loss. Fire broke out around 6:15 p.m. in the basement of the drugstore where photograph processing chemicals were kept. Because of the chemicals, the flames were actually green and purple. Weather conditions made it extremely

difficult to fight the blaze. About 165 firefighters from New London and Waterford worked for four hours in below-freezing temperatures to control the three-alarm blaze. (Courtesy of Stephen Wargo.)

Firefighters work on State Street the following morning, January 23, 1970, at the Starr Brothers Drug Store. At least six hydrants were used to feed 20 to 25 hose lines that crossed over each other on State Street and Main Street to help battle the fire.

Below-freezing temperatures formed ice everywhere the water sprayed. It can be seen hanging off the apparatus and on the road. Firefighter Enrico Rochetti is trying to take a ladder off the truck. Truck No. 1 was frozen for a day in the alley.

New London Fire Department's first class of lieutenants was sworn in on April 1, 1970. Among those were, from left to right, (first row) Chief Romolo Gentilella and city manager C. Francis Driscoll; (second row) Joseph Venditto, Thomas Maher, and Capt. Leo Rochetti; (third row) Enrico Rochetti, Albert Perry, John Beckwith, Leo McCarthy, Walter Nott, Alfred Nunes, Joseph Grippo, and Frederick H. Philopena; (fourth row) James Sullivan and Rosario DiMarco.

Firefighter Donald Venditto was responding to a call in this 1967 Cadillac ambulance when struck by an out-of-state driver in a 1970 Buick at the intersection of Huntington Street and Governor Winthrop Boulevard on August 22, 1970. The driver of the Buick was charged with failure to grant right-of-way to the ambulance and failure to drive in the proper lane.

More side impact damage is visible in this image.

From left to right, firefighters Edward Samul, James Donohue, Ronald J. Samul Sr., and Peter Gilmore get ready to pass out muscular dystrophy flyers for Jerry's Kids on Labor Day 1970 in front of fire headquarters.

An overheated deep-fat fryer was the cause of the fire at the Frosty Delight Pizza Restaurant at 86 Truman Street on October 16, 1970. Three occupants were evacuated without injury by State of Connecticut Motor Vehicle Department personnel who worked next door. $10,000 worth of damage was caused. Firefighter Philip Hancock is standing at the parking meter. Deputy Chief Guido Bartolucci, in the white coat, is at the door.

Firefighters get ready to attack the Bates Woods Dump tire fire in 1971.

New London Fire Department's first EMT class is pictured in November 1972. From left to right are city manager C. Francis Driscoll, firefighters James Flannigan, Alan Parks, Gary Parks, Ronald J. Samul Sr., and John Boyd, Chief Romolo Gentilella, and firefighters David Burchfield, Olin Shaver, and Anthony Basilica.

The 1953 Seagrave 85-foot aerial tiller is on the Whale Oil Row section of Huntington Street. Dr. Carl Wies is seen standing near the column. Dr. Wies was a physician in the community and could be found at many of the fires keeping an eye on the firefighters for their safety.

The Whiton Machine Company building located at 190 Howard Street was destroyed on March 3, 1973, in a general-alarm blaze that began around 11:16 p.m. The fire was suspicious in nature as it was centrally located in the rear of the property near train tracks. Firefighters from the Naval Underwater Systems Center Fire Department and all five Waterford volunteer companies responded. At 5:15 a.m. the following day, Deputy Chief Guido Bartolucci notified WNLC to broadcast over the radio that people working at the Naval Underwater Sound Laboratory were to take an alternate route to work. (Courtesy of Stephen Wargo.)

Chief Guido Bartolucci worked his way up the ranks and became chief on June 18, 1973, and served in this capacity until June 7, 1979.

Fire broke out in this residential home next to the former C. L. Ockford Hose Company No. 5 station at Shaw Street and Howard Street during the mid-1970s. Firefighter Ronald J. Samul Sr. is on the top left ladder, firefighter Thomas McCarthy is turned around, firefighter Armondo Esposito is at the base, firefighter John O'Connor is on the turntable, and the firefighter on top of the right ladder is unidentified.

2nd. alarm - 71 Williams St. - 3/18/75
2 rescued by ladders - 4 firefighters injured

On March 18, 1975, a second-alarm fire broke out at 71 Williams Street at 9:29 p.m. Flames and smoke could be seen coming from the second-floor windows upon the fire department's arrival. Four firefighters sustained minor injuries. More than a dozen residents were left homeless, and $30,000 worth of structural damage incurred.

A funeral procession marches for Chief Romolo Gentilella in August 1976. On the left is Lt. John Beckwith, on the right is Chief Guido Bartolucci, and directly behind are Leo Rochetti and Thomas Maher.

Firefighters Joseph Nott Sr. and Ronald J. Samul Sr. are shoveling out the hydrant near fire headquarters on Bank Street after the blizzard of 1978 pounded the southeastern Connecticut area.

From June 8, 1979, until September 18, 1985, Frederick H. Philopena served the department as chief.

On July 5, 1979, at 10:46 a.m., fire was reported from the Lighthouse Inn at 6 Guthrie Place and a second alarm was called at 10:55 a.m. There was $650,000 in damage. Two city firemen were hospitalized and 13 were injured. The paid firefighters were joined by 22 off-duty men, 25 New London volunteers, and about 50 volunteers from Waterford companies who responded to a general alarm at 11:41 a.m. The fire was not officially declared under control until 1:56 p.m. This is the south-facing view.

This photograph displays the north-facing view of the Lighthouse Inn.

On December 16, 1979, firefighters battle a general-alarm fire that destroyed an apartment house at the corner of Williams and Broad Streets. Ten families were relocated. Fire broke out in the basement of the house and worked its way up the stairways to the roof, causing approximately $250,000 worth of damage.

Conditions upon arrival at 22 Belden Street in February 1982 are shown here. This fire resulted in the first case of arson-murder charges under the new state statute.

Nearly half a city block on Franklin Street was destroyed in a three-alarm fire on March 23, 1982. The blaze was suspicious in origin and spread rapidly to two adjoining buildings, a rooming house, and a fully occupied three-story apartment building, destroying them and forcing the evacuation of 47 residents. Two bodies were found in the fire ruins. This fatal conflagration photograph shows conditions upon arrival.

Firefighter Edward Samul is trying to prevent the spread of flames to adjacent property on the Franklin Street block.

On July 28, 1982, New London firefighters spent an hour freeing this truck, which was driven too far into the sand between Waterford Beach and Ocean Beach. The fire department was called out to an early evening brush fire.

Chief Frederick H. Philopena poses with newly appointed Fire Marshal Ronald J. Samul Sr. in the city council chambers in March 1981. Fire Marshal Samul was previously a fire inspector, a position he was in since November 1980.

Lightning ignited the New London Mills located on Pequot Avenue in the early morning of August 31, 1985. Approximately 250 firefighters responded to the general-alarm fire at 1:40 a.m. There was 4,500 tons of bound paper stored in the building, which helped to fuel the fire along with moderate northerly winds. Deputy Chief Ronald J. Samul Sr. supervised the firefighting efforts as he was acting chief due to Chief Frederick H. Philopena retiring two weeks earlier. The collapse of a section of a 40-foot-high wall along Pequot Avenue crushed the rear end of a car that had been abandoned there due to flooding the day before.

This aerial view shows the New London Mills fire-damaged property along Pequot Avenue.

Firefighters from New London, Groton, Gales Ferry, and Waterford responded to this fiery explosion when a passenger car was struck from behind by a tandem trailer truck on the Gold Star Memorial Bridge on March 24, 1986, at 6:51 p.m. This accident forced the closing of the bridge for more than an hour and a half. Flames were brought under control in about 30 minutes. A pregnant woman and her daughter were killed.

Three
RECENT YEARS
1988–2006

Bridget Yuknat was the first paid female firefighter in the department. She was preceded by Patricia Nunes, who was a member of the Niagara Engine Company, as the city's first female volunteer in 1985. Yuknat was hired on at the age of 24 in 1988. She had worked for four and a half years previously at the Electric Boat Fire Department in Groton. She worked the front lines as a firefighter until 1992 before leaving to start a family. She later reapplied and successfully tested for a position as fire inspector in 2000.

An abandoned two-story house at 26 Blackhall Street was the scene of a two-alarm fire in the early morning hours of November 26, 1987, resulting in one fatality of a 29-year-old city resident. The fire started at the rear of the house and spread through the two floors and onto the roof. Fire inspector Schlink of the New London Fire Department and state trooper Donald Barry of the Bureau of State Fire Marshal's office start the investigative process by taking photographs to gather evidence.

A suspicious two-alarm fire broke out at 103 Truman Street in this two-family house in the early morning hours. The fire was the second occurrence in three days in this neighborhood. There was extensive damage as the fire began on the first floor hallway at the rear of the house and spread quickly through partitions to the second floor and attic. Pictured from left to right are Deputy Chief Kenneth Edwards, Lt. Donald Chapman Sr., Lt. David Pasqualini, and volunteer firefighter Thomas Kane on the ladder.

A fatal accident occurred on Interstate 95 south on April 16, 1988. Engine A-11 and ambulance A-100 responded to the call. Lt. David Pasqualini and firefighters Joseph Nott Sr. and Richard Burgess treat the injured victim.

A 72-year-old man was killed in a fast-moving two-alarm blaze on the morning of March 26, 1990, at 89 Willets Avenue. The fire was brought under control within a half hour. The house was fully engulfed when firefighters arrived. Combustible materials inside of the home, including paneling, insulation, and ceiling finish, contributed to the fire's rapid spread. The grocery store next door had some of its siding melted off due to the intense heat of the fire. A neighbor who lived next door on the opposite side had several windows blown out by the fire.

New London councilman Martin Olsen presented a citation to Lt. Henry Kydd for rescuing a woman and her two children during a fire at 39 Rosemary Street in June 1990. Firefighter Bridget Yuknat and volunteer firefighter Robert Guess were also presented with citations for their lifesaving efforts.

Firefighter Rodrick Ventura (left) and Lt. Joseph Nott Sr. earned A-11's second stork after delivering a baby in September 1990.

A two-alarm blaze destroyed the Book-A-Zine at 172 Bank Street on March 9, 1992. It took firefighters five hours to bring the fire under control. The conflagration could not be fought in the normal manner because it was too dangerous inside due to the large amount of fire inside the building. The roof and upper story collapsed and the front wall facing the street partially collapsed inward under the stress of the dormer. The city ordered the building to be demolished and removed. A volunteer firefighter can be identified by the NLVFD lettering on the turnout coat. The active volunteer system ended by the early 1990s and remains today only in social status.

Thick black smoke poured from the roof of a three-story home on Summer Street on September 1, 1992, and engulfed the Bank Street area. The fire was suspicious in origin as it started on a rear porch and went up the side of the building to the attic, and flames shot out through the roof.

New London Fire Department had its first line-of-duty death on February 1, 1993, when 35-year veteran acting lieutenant John O'Connor suffered a heart attack while battling a two-alarm conflagration. The fire gutted the three-story house at 91 Truman Street. Flames poured out of all four sides of the building. Three residents succumbed to the fire.

The aftermath of the 91 Truman Street four-person-fatality fire is evident the following morning.

St. Patrick's Cathedral in Norwich holds an annual firefighter and emergency service memorial mass in October. In 1998, a memorial service for the fifth anniversary of John O'Connor's passing was given. Pictured from left to right are (first row) Deputy Chief Kenneth Edwards, firefighters Richard Burgess and Jonathan Paige, and Chief Ronald J. Samul Sr.; (second row) firefighters Roger Tompkins, John Linicus, Stephen Wargo, Mark Waters, Joseph Nott Jr., Jeffrey Rheaume, Emile Tackling, and Knute Malinowsky.

The Naval Underwater Systems Center Fire Department located at the Naval Underwater Sound Laboratory in the Fort Trumbull section of the city was manned by federal firefighters who were civilian employees of the navy. The department operated from the 1940s to the closing of the laboratory in 1996. Many city residents did not even know the fire department existed. A 1963 International/FTI 750-gallon-per-minute pumper is pictured. (Courtesy of Stephen Wargo.)

The 1980 Spartan/FTI 1,000-gallon-per-minute pumper was transferred to the city in July 1996 when the Naval Underwater Sound Laboratory closed. A-43 serves as the city's spare engine. (Courtesy of Stephen Wargo.)

On the morning of March 18, 1997, a man was killed and another seriously injured as fire engulfed a two-family home at 9–11 Jefferson Avenue. Firefighters Knute Malinowsky and Jonathan Paige pulled an unconscious man out a side window and were later given citations for the rescue. The rescued man survived.

Firefighters prepare to go in and attack on the ground. A steady stream of water from the bucket, up high, and the ground help to extinguish the flames.

The house was completely destroyed and later torn down.

Pictured from left to right are Lt. Donald Chapman Sr., firefighters John Clark, Philip Hancock, Joseph Nott Jr., Jonathan Cooke, John Linicus, and Kent Reyes, and "Freddie" after attending a public safety education function at the American Legion on Garfield Avenue in 1998.

Firefighter Jonathan Paige is on the run after breaking windows to vent 81 Granite Street on November 19, 1998. An electrical malfunction caused the fire.

Lt. Donald Chapman Sr. and firefighter Joseph Nott Jr. use a saw to cut through to the engine compartment.

Firefighters James Plowden, on the left, and Jeffrey Rheaume carry a disabled occupant down the stairs to safety.

On July 12–15, 2001, Operation Sail came to the port of New London. Better known as OpSail, it was created by Pres. John F. Kennedy in 1961 to promote the cultural exchange and good will through the medium of sail training and through its international tall ship programs. From left to right, Lt. Marc Melanson, Battalion Chief Henry Kydd, Lt. Gary Batch, and firefighters Thomas Starkey, Joseph DiMaggio, and Robert Feliciano pose with the unidentified sailors.

The Los Angeles Fire Department was in the city in spring 2001 to provide mutual aid. Actually, the 2001 American LaFrance was in front of fire headquarters for fire officials to look over for purchase consideration. (Courtesy of Stephen Wargo.)

New arrivals are pictured in front of the United States Coast Guard barque *Eagle* at city pier in September 2001. The city purchased two 2001 Ferrara fire apparatus on Igniter model chassis for $271,218 each.

New arrivals are pictured in front of fire headquarters in September 2001. The Niagara Engine Company No. 1 and F. L. Allen Hook and Ladder Company No. 1 duplex fire station was built after the hurricane of 1938 destroyed the Niagara Engine Company No. 1 station and caused considerable damage to the F. L. Allen Hook and Ladder Company No. 1 quarters. It was decided that the Niagaras and Hooks should be housed in one building. The station was built for $100,000.

On March 30, 2002, an abandoned railroad roundhouse on Fourth Street owned by the New England Central Railroad was destroyed in a two-alarm fire. Ladder truck A-25 responded from the city's North Station on Broad Street. (Courtesy of Stephen Wargo.)

The New London firefighters' pipes and drums band held its first practice on January 16, 2001, and had its first public performance on September 11, 2002, in front of fire headquarters on Bank Street to mark the anniversary of the attack on the World Trade Center. Pictured from left to right are firefighters Mark Waters, Jonathan Paige, and Kevin Johnson, fire inspector Bridge Yuknat, firefighter David Dow, Lt. Bruce Sawyer, Joe Bunkley, firefighter Knute Malinowsky, Bob Copley, and firefighter Christopher Bunkley.

The color guard also participated in the September 11, 2002, memorial service. Pictured from left to right are firefighters Joseph Nott Jr., Reginald Hansen Jr., Jeremy Hynek, and Thomas Feliciano.

Firefighter George Linicus, operating the deck gun, and firefighters Greg Stott and Kristopher Grills, in the tower, attack the flames of a two-alarm fire at 33 Cottage Street on August 19, 2002. (Courtesy of Stephen Wargo.)

Firefighter David Dow pulls the hose lines from the back of the engine A-11. Fire is seen sweeping through the third-story floor from the back to the front.

Firefighter Kevin Johnson, shaking hands, presents to Marine soldiers toys for the Toys for Tots toy drive in December 2002. Firefighters Reginald Hansen Jr., Todd Johnson, and Jonathan Paige were also on hand.

Future firefighters from Germany have their picture taken with New London's bravest in front of fire headquarters in August 2003. Standing from left to right are Battalion Chief Thomas Curcio, firefighters Jeremy Hynek, Stephen Wargo, Kristopher Grills, and Reginald Hansen Jr., Lt. Joseph Stanley, Fire Chief Ronald J. Samul Sr., and unidentified.

For the past 10 years Lt. Victor Spinnato, on the left, has been volunteering as a counselor at the Connecticut Burns Foundation Center in Union. Every summer, for one week, the camp is run for child burn victims. Lieutenant Spinnato uses his vacation time to be with the kids. Thirteen members of the New London Fire Department have joined Lieutenant Spinnato in helping burn victims and their families. (Courtesy of Victor Spinnato.)

Lt. Victor Spinnato, in middle, poses with kids at the Connecticut Burns Foundation Center. (Courtesy of Victor Spinnato.)

The members of the New London Pipes and Drums Band take a moment to have their picture taken with Gov. M. Jodi Rell on the campus of Connecticut College on September 11, 2005. Pictured from left to right are Joseph Bunkley, fire inspector Bridget Yuknat, William Stewart, firefighter Jonathan Paige, Gov. M. Jodi Rell, David Paige, fire inspector Vernon Skau, and firefighters Kristopher Grills and Knute Malinowsky. (Courtesy of Donald Chapman Jr.)

Chief Ronald J. Samul has led the department into the 21st century. He has served as fire chief since December 20, 1985, upon being promoted from the deputy chief position he filled since November 1984. Chief Samul began his firefighting career as a volunteer with the F. L. Allen Hook and Ladder Company No. 1 in the mid-1960s before being drafted into the Vietnam War. Upon his return home from the war, he was hired as a paid firefighter in 1970. Before becoming chief, he served as a fire inspector, the fire marshal, and the deputy chief. Under his leadership, the department transitioned to a career department. He is the second-longest serving chief.

Chief Engineers of the New London Fire Department

1850–1853
Rial Chaney

1854
W. W. Gallaher

1855–1863
Artemer G. Douglas

1864
F. L. Allen

1865–1866
A. J. Burgess

1867
G. E. Starr

1868–1869
George Williams

1870
A. J. Burgess

1871–1887
W. B. Thomas

1888
Peter McMullen

1889
Vacant

1890–1891
J. H. Brown

1892
Thomas Kiley

1893
Alonzo W. Sholes

1894–1899
Charles L. Ockford

1900–1922
John H. Stanners

1923–1926
Charles H. Rose

May 20, 1926–June 23, 1953
Thomas H. Shipman

July 6, 1953–September 6, 1959
Frank Sullivan

September 6, 1959–January 7, 1965
Joseph M. Corkey

January 15, 1965–March 1, 1969
James Spadaro

March 1, 1969–May 25, 1973
Romolo Gentilella

June 18, 1973–June 6, 1979
Guido Batolucci

June 8, 1979–September 18, 1985
Frederick H. Philopena

December 20, 1985–Present
Ronald J. Samul Sr.

INDEX

arson-murder, 97
charity, 63, 87, 123
chief engineers
 Bartolucci, Guido, 91, 127
 Corkey, Joseph M., 41, 127
 Gentolella, Romolo, 81, 85, 89, 94, 127
 Philopena, Frederick H., 95, 99, 127
 Rose, Charles H., 25, 32, 38, 44, 46, 127
 Samul Sr., Ronald J., 126, 127
 Shipman, Thomas H., 47, 55, 127
 Spadaro, James, 80, 127
 Stanners, John H., 13, 127
 Sullivan, Frank, 69, 72, 127
citations, 106, 111
C. L. Ockford Hose Company No. 5, 35, 36, 54, 57
Connecticut Burns Foundation Center, 124
EMTs, first class, 89
fatalities, 69, 97, 98, 102, 104, 105, 108, 111, 112
female, first paid, 103
fire prevention, 28, 81, 113
fires
 Bank Street, 58, 67, 74, 75, 107
 Barrows Building, 59
 Bates Woods Dump, 88
 Belden Street, 97
 Blackhall Street, 104
 Brainard Street, 76
 Calmon Jewelers, 82–84
 Carradino's Bakery, 78
 Cottage Street, 122
 Dan O'Shea's, 74
 Devlin's Ringside restaurant, 58
 Empire Theater, 74
 Fourth Street, 120
 Franklin Street, 98
 Frosty Delight Pizza Restaurant, 87
 Golden Street, 69, 74
 Granite Street, 114
 Hallam Street loading dock, 77
 Howard Street, 57, 90, 92
 Jefferson Avenue, 111, 112
 Lighthouse Inn, 96
 Main Street, 78
 Mohican Hotel, 72
 New England Central Railroad roundhouse, 120
 New England Steamship Company pier, 53
 New London Lighting Fixture Company, 67
 New London Mills, 100, 101
 New London Wholesale Grocery, 74
 Pequot Avenue, 100, 101
 Pequot Hotel, 38
 Quintillian's Clothing Shop, 75
 Salvation Army Building, 76
 Second Congregational Church, 49
 Sparyard Street, 51
 Starr Brothers Drug Store, 82–84
 State Street, 59, 72, 82–84
 Summer Street, 107
 Swift Company Wholesale Meat Distributor, 64, 65
 Tait Brothers Ice Cream Company plant, 60
 Truman Street, 87, 104, 108
 Whiton Machine Company, 90
 Willets Avenue, 105
 Williams Street, 93, 97
F. L. Allen Hook and Ladder Company No. 1, 19, 20, 68, 70, 71, 79, 119
hurricanes
 Carol, 70, 71
 1938, introduction, 51
Kiely, William, 20, 21, 33
Konomoc Hose Company No. 4, 29–34
Konomoc Ladder Company No. 4, 33, 34, 49, 61, 65, 68
lieutenants, first class, 85
Nameaug Engine Company No. 2, 22–25, 76
Naval Underwater Systems Center Fire Department, 110
Niagara Engine Company No. 1, 10, 12, 14–17, 56, 68, 70, 71, 79, 119
Northwest Engine Company No. 7, 42, 45, 51, 62, 72
Northwest Hose Company No. 7, 42–45
O'Connor, John, 108, 109
"Old Maud," introduction, 15
Pequot Engine Company No. 6, 37, 39–42, 52
pipes and drums, 121, 125
Uniformed Firemen's Benevolent Association, 62, 63, 66
W. B. Thomas Hose Company No. 3, 26–29, 62, 79